Vincent

THE LIFE AND WORKS OF

Vincent
VAN GOGH

—— Janice Anderson ——

A Compilation of Works from the
BRIDGEMAN ART LIBRARY

p

This is a Parragon Book
This edition published in 2003

Parragon, Queen Street House, 4 Queen Street, Bath BA1 1HE, UK

Copyright © Parragon 1994

ISBN 1-85813-913-9

Printed in China

Designer: Robert Mathias

VINCENT VAN GOGH 1853-1890

Vincent

VINCENT VAN GOGH does not fit into any painting school, though his superb colour sense can be traced back to Impressionist theories. It was after he joined his brother Théo in Paris and met the artists who were by that time known as 'Impressionists' that van Gogh began to abandon the dark tones in which he had hitherto painted in favour of the pure primary and secondary colours, and to adopt the broken brushwork which gave a feeling of light and air to Impressionist pictures. He also began to paint out of doors, a habit that stayed with him until the end of his life. The technique he created for himself of decisive impasto brushstrokes, applied without hesitation or second thoughts, enabled him to paint quickly and to produce a vast volume of work in the last two and a half years of his life.

Vincent William van Gogh was born in Groot-Zundert, a small town in Brabant, on 30 March 1853. His father was a Protestant pastor and van Gogh inherited from him the strong religious feeling about life and nature which characterized his work. He and his younger brother Théo were close friends, and Théo not only encouraged his brother's desire to be a painter but actually supported him financially for the last few years of his life. Vincent's earliest employment was in the Paris, Brussels and London branches of Goupil et Cie, an art dealer business founded by his uncle. He later tried his hand at teaching in London

and then worked as a preacher in the mines and poor agricultural districts of Brabant. It was here that van Gogh began to express his feelings about the people around him in his drawings. He lived as poorly as they did, with a prostitute whom he had taken into his care, but his dedicated Christianity was misunderstood and he was censured by his local church.

Later, an unrequited love affair drove him to attempt suicide. By 1880, van Gogh had turned to the study of art in Brussels and The Hague. Eventually, he joined his brother Théo, now working for Goupil et Cie, in Paris. Here, van Gogh met Degas, Pissarro, Signac, Seurat, Toulouse-Lautrec, Monet and Renoir and discovered his true vocation.

After two years in Paris, during which time he painted over 200 pictures with his brother's financial help, van Gogh went to Arles in the south of France. He took a studio in a building christened the Yellow House and there waited for his friend Gauguin to join him. Gauguin was reluctant, but as Théo was his art dealer, he felt obliged to agree to spend some time with Vincent. The two men settled down in Arles but there was a lot of tension between them, much of it due to van Gogh's intense nature, and Gauguin announced that he was returning to Paris. One evening, he found himself being followed through the public gardens in Arles by van Gogh who was making threatening gestures with a razor blade or knife. Gauguin slept that night at a hotel and next day returned to the Yellow House to find that van Gogh had been taken to hospital. He had cut off part of his ear and given it to one of the prostitutes at the bar he and Gauguin frequented.

After this, van Gogh voluntarily retired to an asylum for the insane at St-Rémy-de-Provence where he hoped to

restore his self-confidence and his mental stability. While there, he painted incessantly and wrote to his brother and Gauguin to reassure them that he had recovered. A year later he had a second attack of madness. Others would follow; van Gogh realised that he was the victim of an incurable illness.

In 1890 he left St-Rémy and the warm south and, on the advice of Pissarro, went to Auvers-sur-Oise where a Dr Gachet could look after him. Here, he continued painting but after a visit to Paris where he learned about his brother's financial difficulties and the worrying illness of his baby son, van Gogh's madness recurred. One day while out painting in Auvers he shot himself in the chest. The wound did not seem too bad. Dr.Gachet dressed it and called Théo from Paris. Two days later, on 29 July, 1890, Vincent van Gogh died. He was buried in the cemetery in Auvers.

▷ **The Potato Eaters** 1885

Print

MUCH OF THE WORK that van Gogh did in Holland before going to Paris was dark and heavy, expressing his feelings for the poor and underprivileged miners and agricultural workers. It also expressed his deep religious compassion for them and the idea that their toil was not in vain. As he wrote to his brother Théo, he wanted to convey 'the idea that these people in the lamplight . . .have worked the earth and that my painting gives dignity to manual work and the food they have themselves earned through honest toil.' He did many versions of the 'Potato Eaters' theme in 1885.

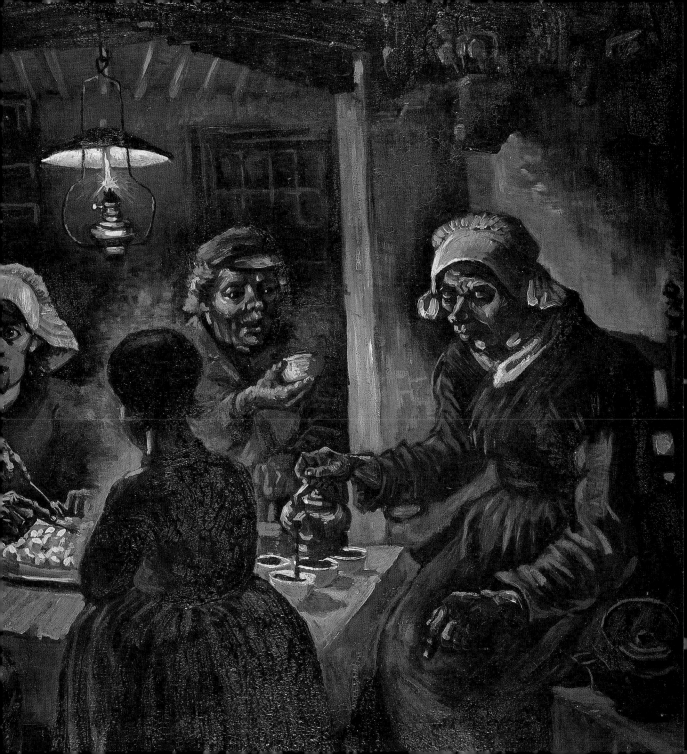

Detail

▷ **Moulin de la Galette** c.1886

Oil on canvas

FOR VAN GOGH, the Moulin de
la Galette, of which he painted
many views in 1886 and 1887,
was not so much the lively
dancing place beloved of the
Impressionists, as a
picturesque relic of a past
rural life on the fringes of
Paris. The Moulin was one of a
number of windmills on the
hill of Montmartre and had
been converted into a bar,
restaurant and dancing place
where the young Paris
bourgeoisie met. Van Gogh
had gone to Paris to be near
his brother and had begun
associating with other painters
who had introduced him to
many new ideas. As is evident
from this summer-time
painting, which is much
brighter than his earlier work
in Holland, theories of light
and colour had been among
those ideas.

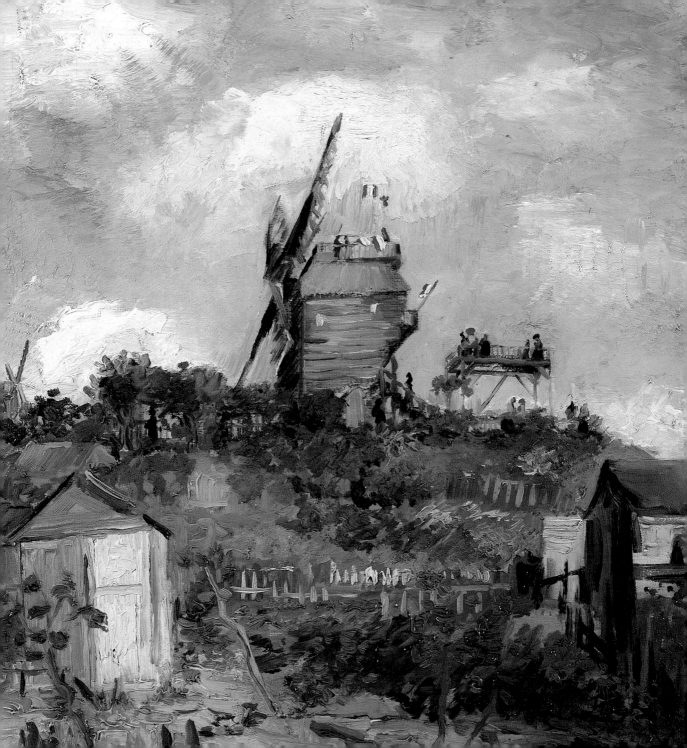

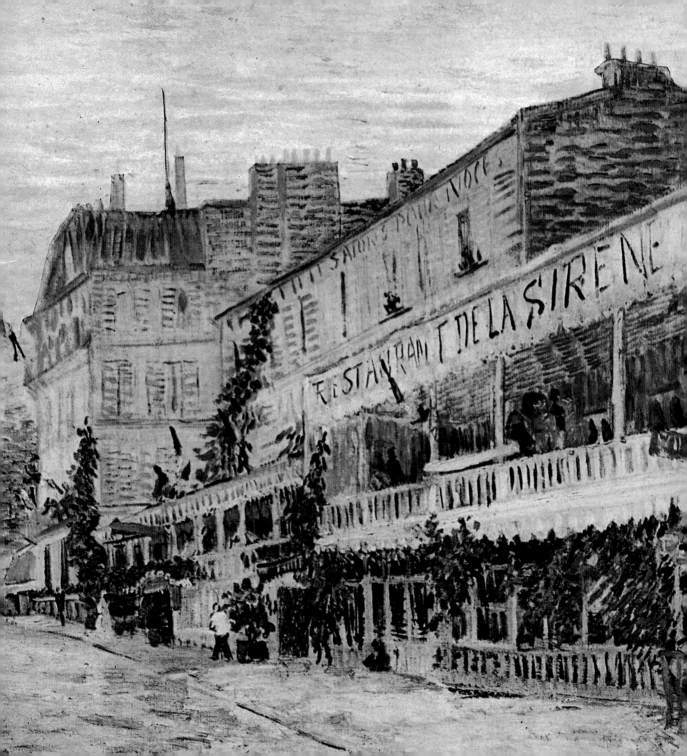

◁ **Restaurant de la Sirène at Asnières** 1887

Oil on canvas

THIS CHARMING PICTURE of the restaurant at Asnières, near Paris, is in an Impressionist style which van Gogh had picked up from other painters he had come to know in Paris. The light, colourful brush strokes are a world away from the heavy brown impasto of his Dutch pictures and express his own change of spirit: the world now seemed full of hope and optimism, and a belief in God's goodness now seemed, not so much a compensation in some afterlife for the sorrows of this one, but something available for anyone with a mind open to the beauty of nature.

The Allotments c.1887

Oil on canvas

▷ *Overleaf pages 14-15*

VAN GOGH DID SEVERAL paintings of the small vegetable gardens which covered much of the hill of Montmartre, including in delightful detail their garden sheds, post and wire fences, even sunflowers in several, and, of course, the windmills which still stood out on the hill-top. The allotments in this painting were near the Moulin de la Galette, which was no longer a working mill but a café and dance-hall. To van Gogh, with his love of the countryside, the allotments must have seemed the last vestiges of rural life in Paris, at a time when the city was expanding rapidly.

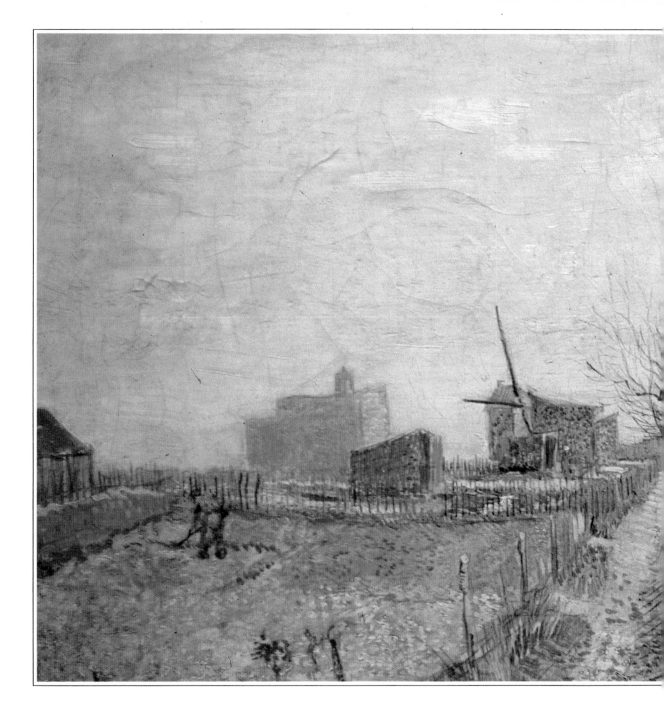

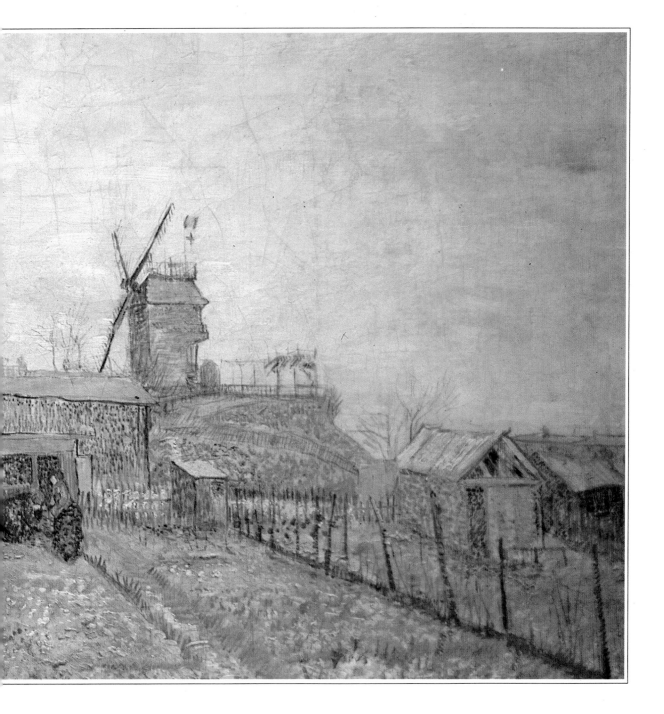

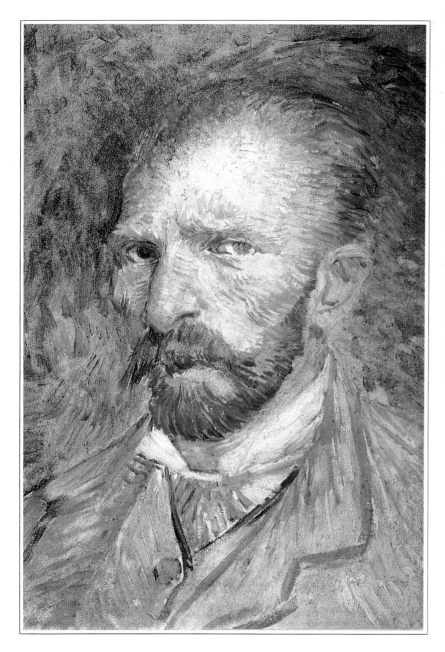

◁ **Self-portrait** 1887

Oil on paper

IN THIS SELF-PORTRAIT, painted in Paris in the spring of 1887, van Gogh is neatly dressed in a jacket and blue cravat. It shows him experimenting with Impressionist techniques and using short broken brushstrokes to describe the structure of the head. During this time in Paris van Gogh was meeting other artists and broadening his artistic horizons. He was also beginning to work at such a speed that he was able to produce in just a few years the same amount of work that other artists created over a lifetime.

▷ **Woman at a Table in the Café du Tambourin** 1887

Oil on canvas

THIS PAINTING of Agostina Segatori, a former model who ran the Café du Tambourin in Paris, was painted not long after van Gogh had arrived in the city, and in style falls between the Dutch paintings and his later work. The emotional motivation is evidently still van Gogh's compassion for toil-worn people that had prompted the 'Potato Eaters' series. Here, though, the colour is brighter and the airy composition shows the influence of Japanese art which was the rage in Paris at the time and which van Gogh acknowledges in the prints hung on the wall.

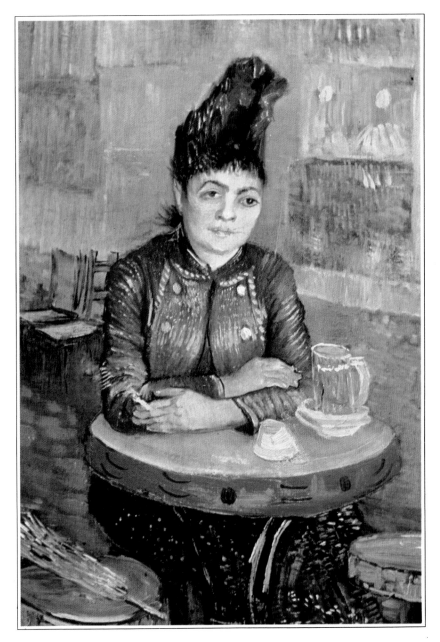

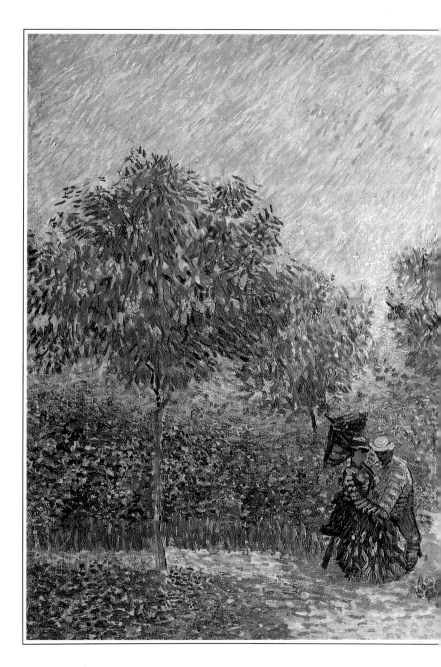

▷ **The Park at Asnières** 1887

Oil on canvas

ONCE SETTLED IN PARIS, van Gogh launched himself into a fever of painting, completing nearly 230 pictures in the two years he was in the city, more than in any other comparable time in his life. Gradually, the new ideas he was encountering, especially from among the followers of Impressionism, found their way into his pictures. There were short, all-over brushstrokes with the flavour of Pissarro and Monet, though soon van Gogh was to develop them in his own, inimitable way. Perhaps the couples in this picture represent van Gogh's own thwarted yearnings for companionship at this period of his life.

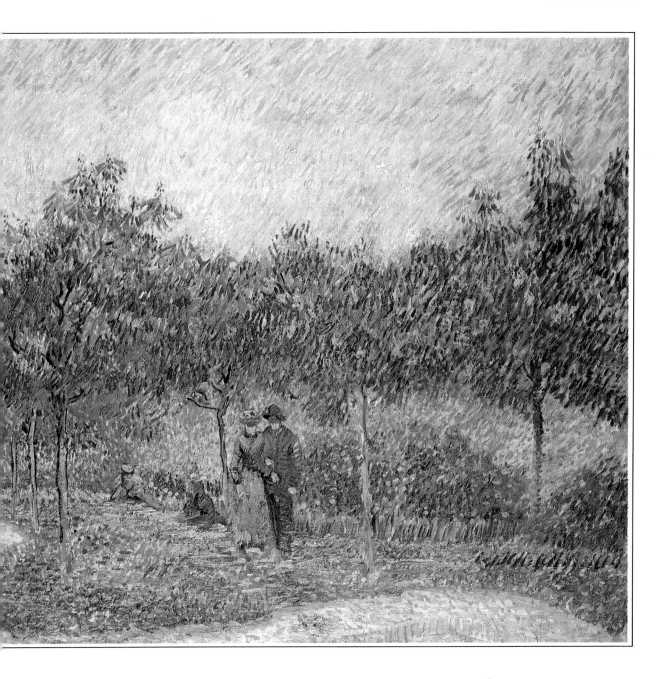

▷ **Edge of a Wheatfield with Poppies and a Lark** 1887

Oil on canvas

UNLIKE SOME OF van Gogh's paintings of fields of grain, which he often depicted ripe and ready for harvesting under a hot sun, this one has a gentle, spring-time quality about it. The stalks of wheat are still green, the sky is a mild blue and the bird soaring upwards seems a symbol of hope and new life. The painting was done at a time when van Gogh was becoming increasingly confident in his use of the new techniques he had been developing in Paris. The brushstrokes are firm and decisive and used to describe the wheat rather than to build up atmosphere, in the Impressionist manner of painters like Monet.

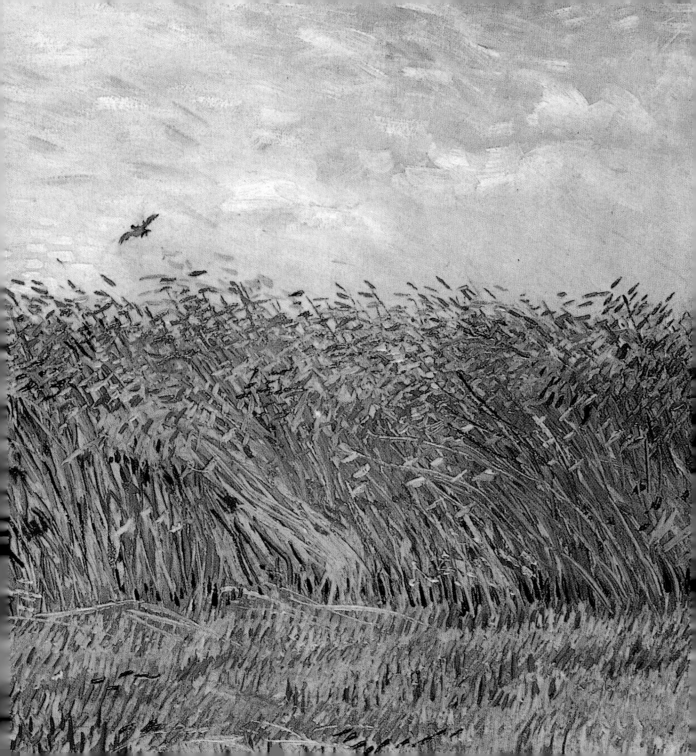

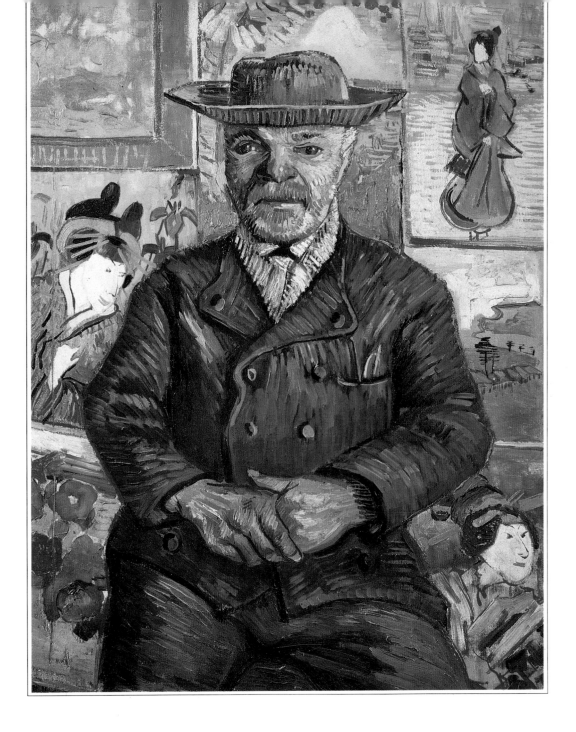

◁ **Père Tanguy** 1887

Oil on canvas

VAN GOGH DREW and painted Père Tanguy several times in 1887, the year after he had arrived in Paris to join his brother Théo. Julien-François Tanguy was an artist's colourman who also sold paintings and was a good friend to the Impressionists. In this painting, van Gogh surrounds him with the Japanese prints that were much in vogue with the new painters and which gave them ideas for their own work. Writing to his brother Théo, van Gogh said, 'I was sorry afterward not to have asked old Tanguy for the paints all the same, not that there would be the least advantage in doing so – on the contrary – but he's such a funny old soul, and I think of him many a time.'

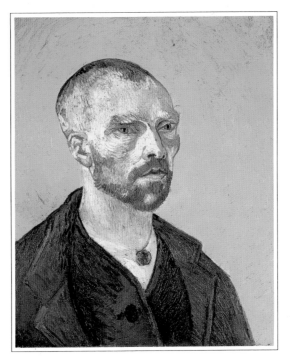

△ **Self-portrait** 1888

Oil on canvas

THIS STARK SELF-PORTRAIT was painted for Gauguin before they began to share the Yellow House in Arles and may have confirmed the doubts in Gauguin's mind about the wisdom of living with van Gogh. Gauguin was indebted to Théo van Gogh, who exhibited and tried to sell his work through his gallery, and felt impelled to agree to keep Vincent company. As well as the painting, Gauguin received a letter from van Gogh which, since it discussed his exaggerated personality and his aim to have a character of a simple bonze worshipping the Eternal Buddha, was not reassuring. Van Gogh himself, lonely and cut off from the artistic ambience of Paris, was emotionally keyed up for many weeks in anticipation of Gauguin's arrival.

▷ **Sunflowers** 1888

Oil on canvas

DESPITE HIS SETBACKS and misfortunes, van Gogh had a remarkably optimistic view of life and human beings and was a great believer in God's goodness. Sunflowers, of which he painted many pictures, were a symbol of the power and beneficence of life. In a letter to Théo he wrote, 'I'm painting with the gusto of a Marseillais eating bouillabaisse, which won't come as a surprise to you when you learn that I am painting sunflowers . . .' Van Gogh was working feverishly because he had heard that Gauguin was on his way to Arles and wanted to decorate his room with sunflower paintings, symbols of the sunshine in which they would both work.

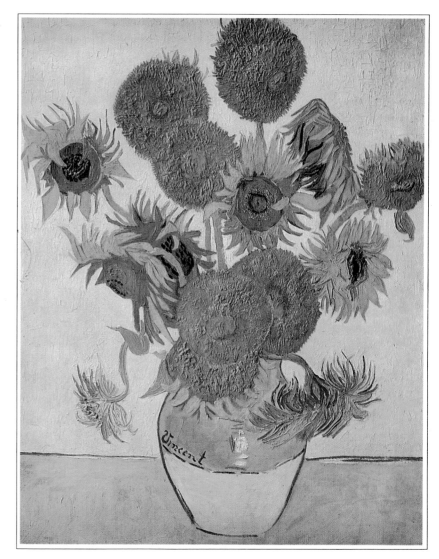

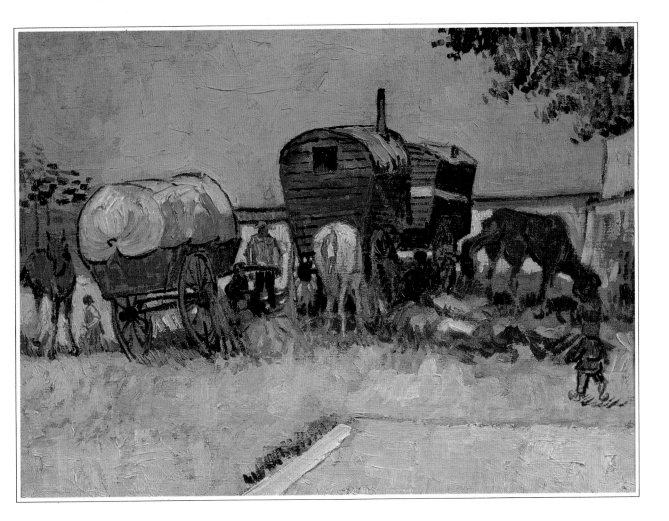

△ **The Gipsy Encampment** 1888

Oil on canvas

THE CHEERFUL COLOUR of these gipsy caravans give the picture an optimistic outgoing character. Unlike many of his artist contemporaries, van Gogh did not have the opportunity to travel abroad in search of inspiration. The constraints of his life and the state of his health precluded such adventures. Perhaps he saw in the gypsy caravans, as he had in the fishermen's boats at Saintes-Maries-de-la-Mer, a life of romantic adventure.

▷ **The Dance-hall at Arles** 1888

Oil on canvas

GAUGUIN LIKED to frequent dance-halls and consort with prostitutes; while he was at Arles, van Gogh accompanied him, though he lacked the temperament for this kind of life. In this hot and crowded scene he shows little of the *joie de vivre* which someone like Toulouse-Lautrec, for whom dance-halls and brothels were a second home, put into his pictures. In van Gogh's painting, even his new freer style seems to have deserted him, though this was, perhaps, due to the influence of Gauguin and his tendency to paint in flat colours with heavy lines.

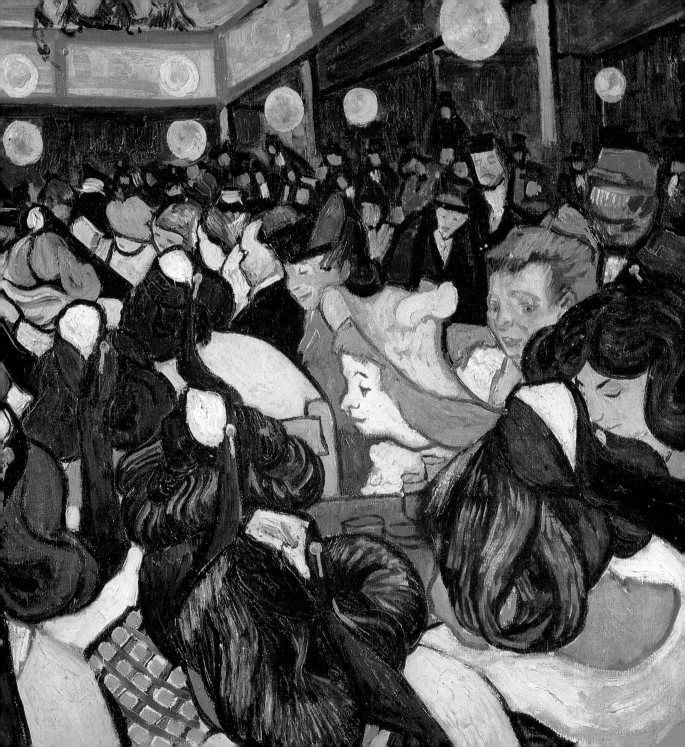

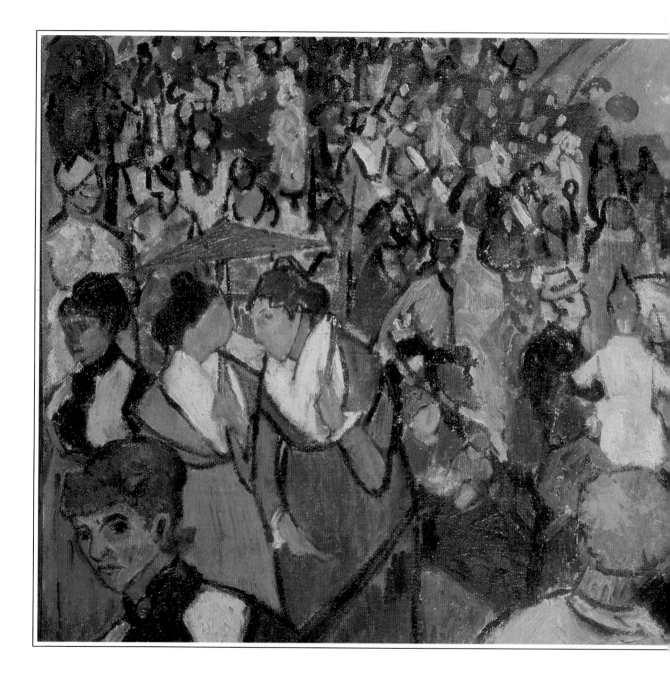

◁ **The Arena** 1888

Oil on canvas

THE ROMAN ARENA at Arles has long been used for festivals, among the most important of which are bullfights, carried on today, as in van Gogh's time, in both the Spanish and the Camargue styles. In this painting, van Gogh has kept the corrida, which was the occasion for his visit, in the left background of the picture and concentrated on the spectators, some of whom seem to have had little interest in the main event. Although the painting is done in an unusual style, it makes a pair with another of van Gogh's scenes of the life of Arles, The Dance-hall at Arles.

▷ **Seascape at Saintes-Maries-de-la-Mer** 1888

Oil on canvas

VAN GOGH MADE only one trip to the Mediterranean coast from Arles. This was in May 1888, when he spent a week at Saintes-Maries-de-la-Mer. He was full of excitement at seeing the sea which, like everything else in southern France, was so different from the seas of the north. During his brief stay he completed two canvases and made a number of sketches for later reference. He was fascinated by the colour of the sea, which he described as having the colour of mackerel because it was so changeable. The best known of van Gogh's sea pictures is probably *Little Boats on the Beach;* this one, in contrast, makes more of the human element: the fishermen who are shown putting out to sea.

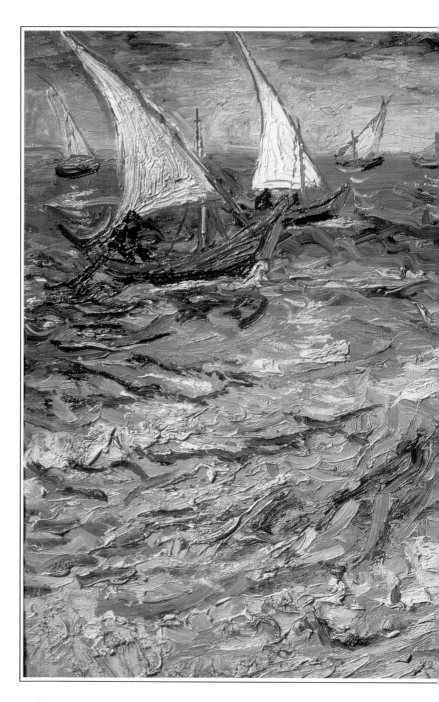

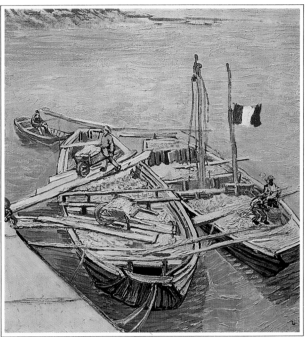

△ **Boats with Men Unloading Sand** 1888

Oil on canvas

THE TWO BARGES, from which the men are unloading sand, are brilliantly contrasted against the green of the river, and the stone parapet of the quay in the foreground evokes brilliant sunshine. The French *tricolore* at half-mast may be symbolic.

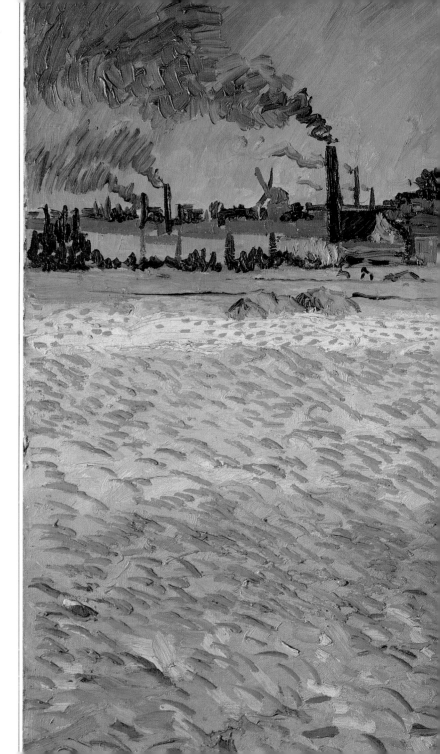

▷ **Sunday Evening
at Arles** 1888

Oil on canvas

WHEN VAN GOGH went to Arles
it was a small forgotten town
on the banks of the Rhône
with the relics of its former
glory in Roman times scattered
in neglected ruins about the
streets. The arena, the baths
and the theatre were
overgrown with grass and van
Gogh took little notice of
them. Instead, he looked for
themes for his paintings by the
river and the countryside near
the town. This view shows the
town dramatically back-lit by
the setting sun while the fields
of ripe grain match in intensity
of colour the sun itself. Van
Gogh was to use this field
again as the setting for his
painting of a peasant sowing
wheat seed.

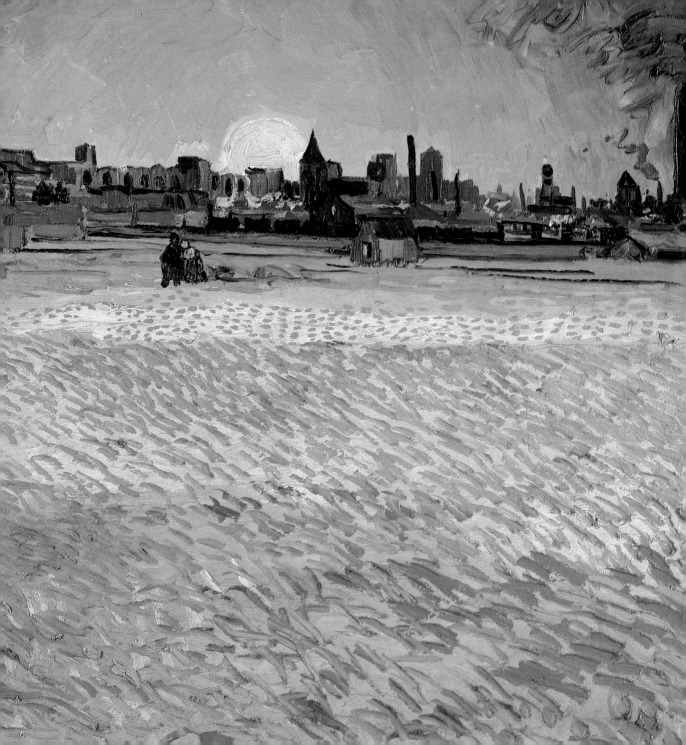

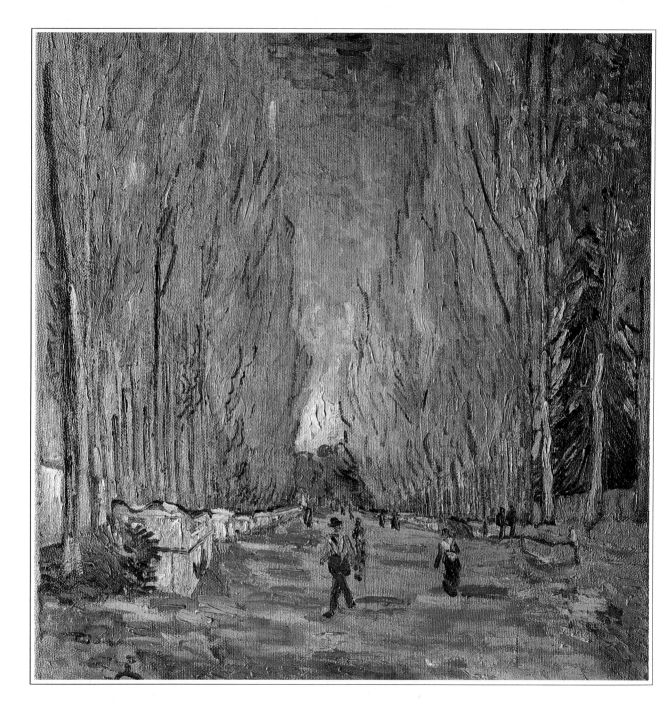

◁ **Allée des Alyscamps** 1888

Oil on canvas

THE ALYSCAMPS is a tree-lined avenue of Roman sarcophagi in Arles, and a popular place for a promenade in van Gogh's time. He painted it in autumn, with the fallen leaves making a rich red carpet on the ground. The red and brown tones of the leaves are contrasted with the blue of the tree trunks, a colour which is carried on in a lighter tone up the trees. Gauguin was still in Arles at this time and no doubt the two men walked under the trees and engaged in what were becoming more and more heated discussions about art; usually, van Gogh gave way to Gauguin, treating him with the deference of a student for a teacher.

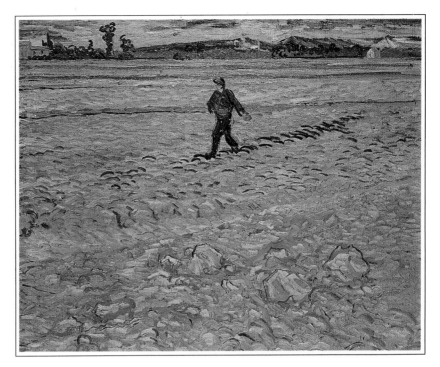

△ **The Sower** 1888

Oil on canvas

INSPIRED BY MILLET'S pictures of sowers, gleaners and milkmaids, van Gogh had been interested in the subject of the work of the countryside since his youth. Agricultural work was symbolic, representing man's role in bringing out the goodness of God's earth. This Rousseau-esque concept was part of the essential philosophy of the Romantic movement, as well as being central to van Gogh's strong religious feelings. In this painting, the sower is seen at work against a background of the city of Arles, with a strong colour contrast between the earth and sky.

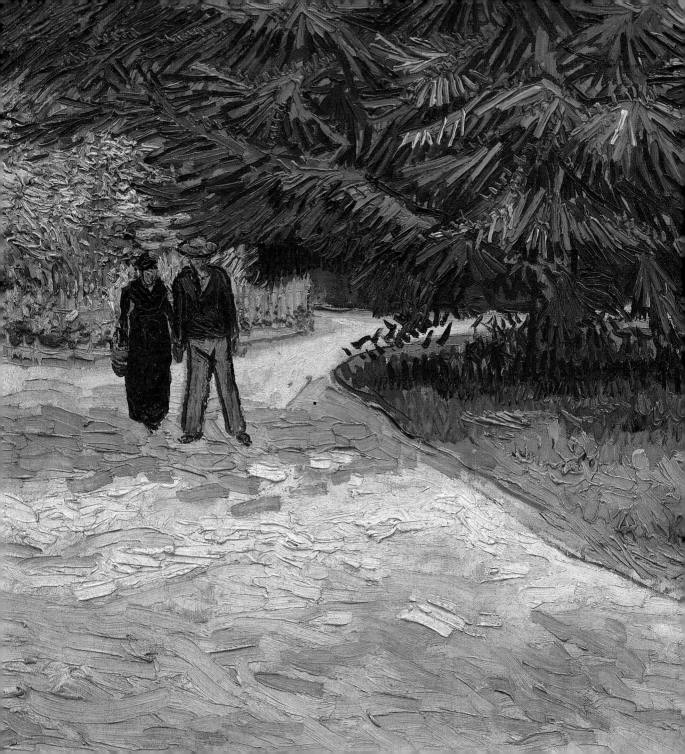

◁ **The Poet's Garden, Arles** 1888

Oil on canvas

VAN GOGH CHRISTENED the small park in front of the Yellow House in Arles the Poets' Garden on account of Boccaccio and Petrarch, both of whom had lived in the south of France, Petrarch at Fontaine de Vaucluse near Avignon, where he had retired to nurse his sorrow at his unrequited love for Laura. The figures in this painting could be lovers, walking hand in hand in the shadow of the tree.

▷ **Entrance to the Public Gardens at Arles** 1888

Oil on canvas

THE YELLOW HOUSE in which van Gogh and Gauguin lived at Arles was at Place Lamartine, near the river and the station. From here the two artists would walk to the Public Gardens along the Rue Voltaire and past the Roman arena and theatre. As they walked they discussed, often heatedly, their contradictory views on art. It was during one of these walks that Gauguin decided that he could no longer remain at Arles. He told van Gogh, who was so upset that it tipped the balance of his febrile mind into his first attack of madness.

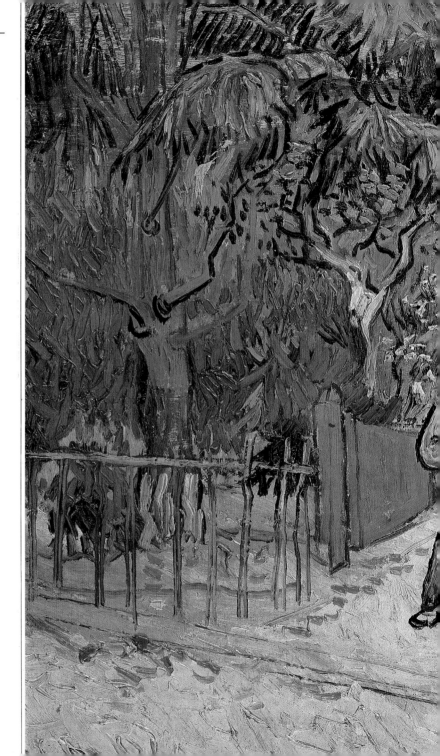

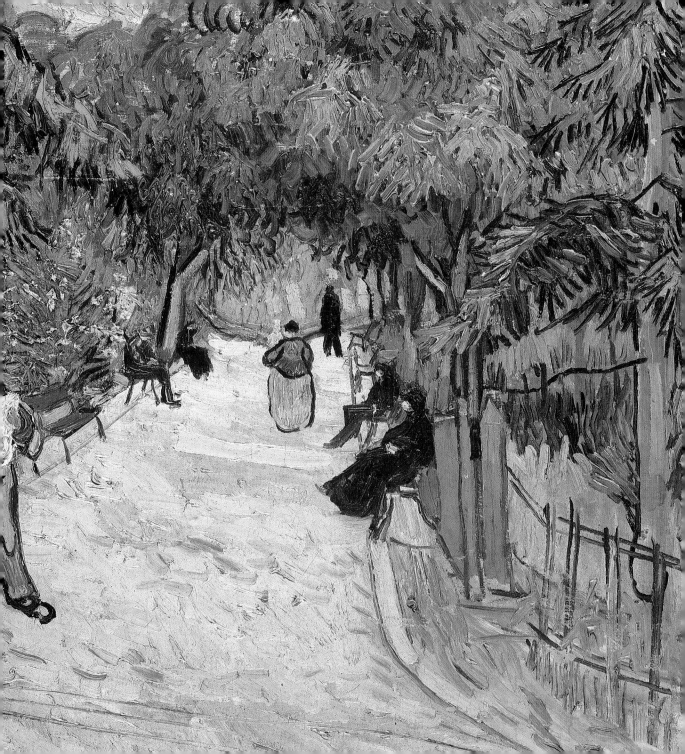

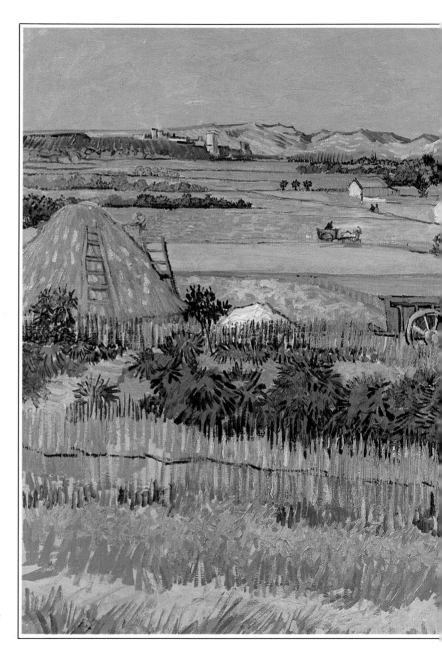

▷ **The Harvest** 1888

Oil on canvas

THE FIELDS OF RIPE CORN ready for reaping filled van Gogh's mind in the autumn following his spring visit to Saintes-Maries-de-la-Mer. The wheatfields lay to the south-east of Arles in an area called Le Crau, once swampy but now rich agricultural land. The agriculture context reminded him of the fields of Brabant, but here the fields were filled with sunshine and colour, fruit trees abounded instead of root crops, and the people, though poor, looked happy. Various tones of yellow predominate in this painting, contrasting with the violet tones of the Alpilles mountains, where van Gogh loved to walk, and the green of the sky.

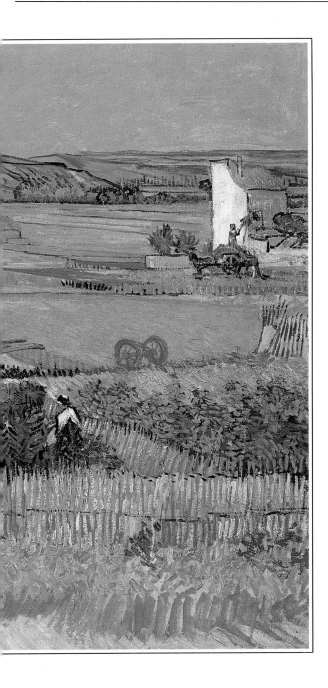

Postman Roulin 1888

Oil on canvas

▷ *Overleaf page 42*

WHENEVER HE COULD, van Gogh persuaded the people of Arles to pose for him, and thus recorded for posterity the doctors and tradespeople who were part of his life. The postman Joseph Roulin was a simple man who had not come across painters before and always looks a little awkward and self-conscious in van Gogh's several portraits of him. Van Gogh described Roulin in a letter to a friend as being 'A Socratic type no less Socratic for being a bit of an alcoholic, and consequently of high colour. His wife had just given birth, the good man glowed with satisfaction. He's an awful old Republican, like Père Tanguy. He held himself so stiffly when he posed, which is why I painted him twice, the second time in a single sitting.'

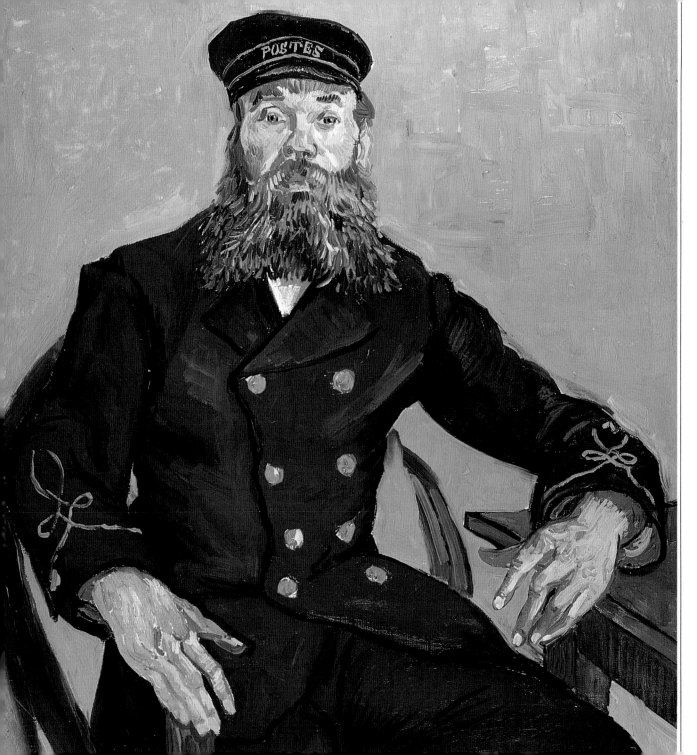

▷ **La Berceuse** c.1888

Oil on canvas

'LA BERCEUSE' – a woman who rocks an infant – is Madame Roulin, the wife of the postman whose family were all painted by van Gogh. She had had another baby at the time van Gogh came to Arles. As with one of the pictures of Monsieur Roulin, van Gogh used a flowered background, resembling the wallpapers that French country people like to have on their walls. As with other portraits, there is more than one version of La Berceuse. Its composition is very simple, in keeping with people like the Roulin family, who liked brightly coloured chromolithographs and barrel-organ music. Such people, van Gogh thought, sometimes knew more about the simple truths of life than smart people who went to the salons.

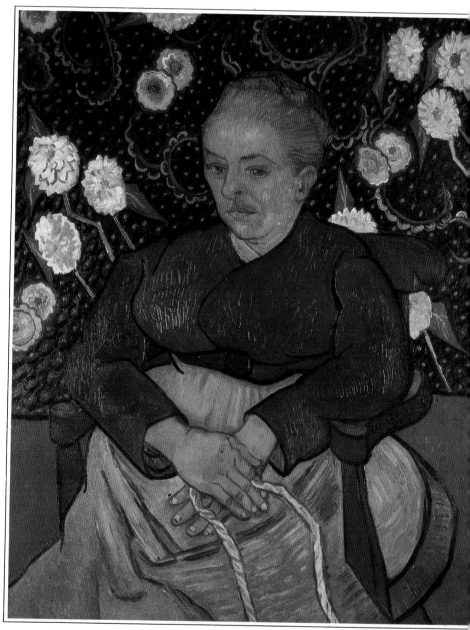

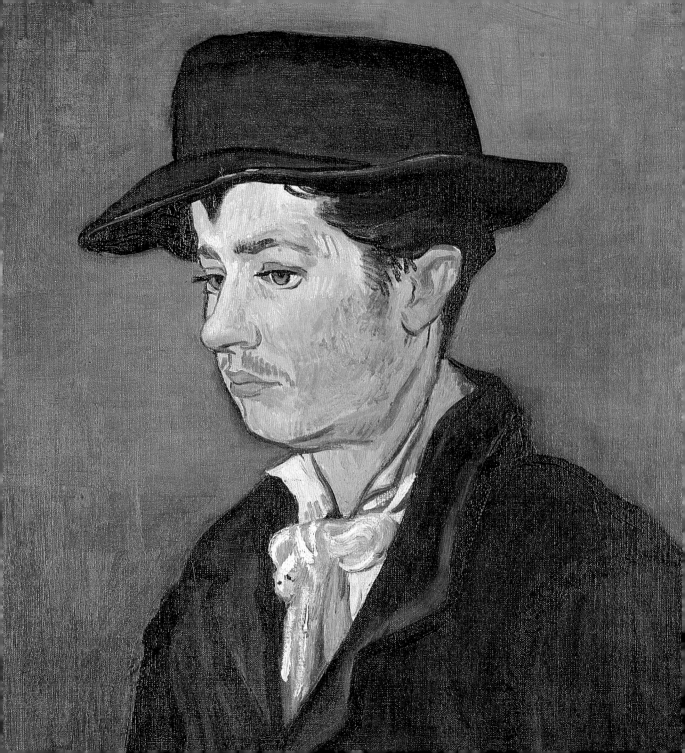

◁ **Portrait of Armand Roulin** 1888

Oil on canvas

THE FAMILY of the Arles postman, Joseph Roulin, were willing sitters for van Gogh, and the painter was delighted when he managed to 'do' the complete set, which consisted of Joseph Roulin, his wife, their teenage son, Armand, 11-year-old Camille and the baby. There were two portraits of Armand. In this one, he looks more like a 17-year-old apprenticed to a blacksmith (which he was) than the debonair youth, with smart black hat and yellow jacket, of the other portrait. Van Gogh told his brother, Théo, in one of his many letters from Provence, that he had made a mass of studies for the Roulin family series; perhaps they would 'provide me with some property when I'm forty', he wrote in his usual optimistic way.

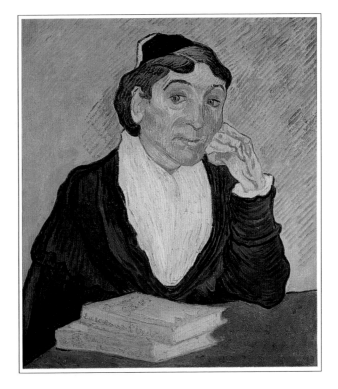

△ **The Woman from Arles** 1888

Oil on canvas

VAN GOGH DID several versions of this subject, a woman in local costume. The sitter was a Madame Ginoux who, with her husband, had befriended the painter when he came to Arles. This is a slightly simplified version of the subject, in which the white of the woman's shawl is echoed by the white of the books on the table in front of her.

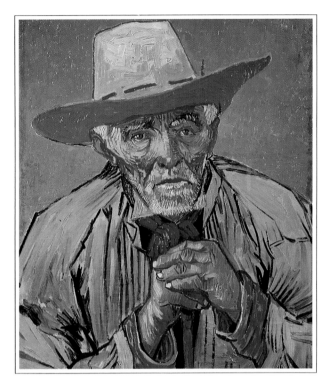

△ **Old Peasant** c.1888.

Oil on canvas

THE OLD ARLESIAN PEASANT, Patience Escalier, may be reminiscent of the Brabant peasants painted by the young van Gogh, but, depicted as he is wearing his yellow straw hat and blue smock, he is an altogether brighter and more cheerful figure – a man to whom the earth is bountiful. The sunshine of the south confirmed in van Gogh his idea of how good and fruitful life could be, and the colours of this painting – yellow, blue and red – are the colours of life.

▷ **Café Terrace, Place du Forum, Arles, at Night** 1888

Oil on canvas

THIS IS ONE OF VAN GOGH'S most powerful pictures of the café which he and Gauguin frequented at Arles. Van Gogh had become enthused by the idea of night painting and the café with its yellow lights against the night sky made a good subject. The lemon yellow of the awning spreads across the bottom part of the picture, turning to orange on the terrace and contrasted on the wall and table tops by two kinds of green. The orange tone is picked up in the lighted windows and among the cobbles and the green by the tree. Van Gogh was applying Impressionist ideas of colour but in a way that led to the Fauve painters and Matisse.

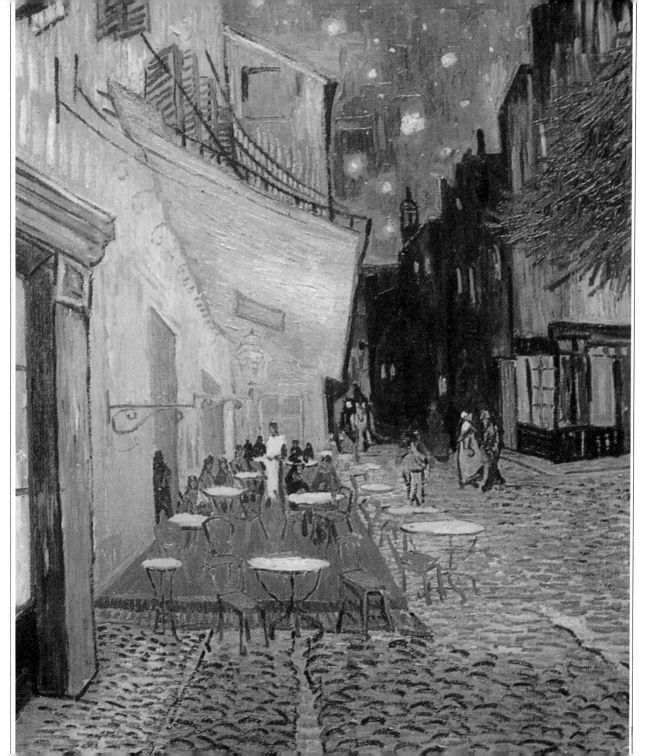

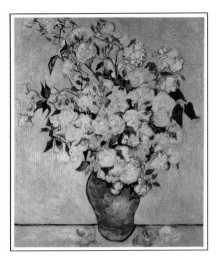

△ **White Roses** 1888

Oil on canvas

THE FLOWERS THAT FEATURE most memorably in van Gogh's paintings are the sunflowers he painted to decorate Gauguin's room at Arles, the irises from the asylum gardens in St-Rémy-de-Provence, and white roses. Unlike Renoir, van Gogh did not seek to find the flesh tints in roses but painted them, as he did with so many things that caught his eye, because they were a part of nature that happened to have stirred in him a spontaneous response.

▷ **Red Vineyard at Arles** 1888

Oil on canvas

THE AUTUMN VINEYARD and its grape-pickers inspired this painting which was the only one that his brother Théo managed to sell during van Gogh's lifetime. It was bought by Anne Boch, sister of the Belgian painter Eugène. In describing the painting to his brother, van Gogh said that it was painted after rain with the setting sun turning the ground violet and the leaves of the vines red 'like wine'. The green tinge in the sky was put in to contrast with the warm red tones which dominate the composition.

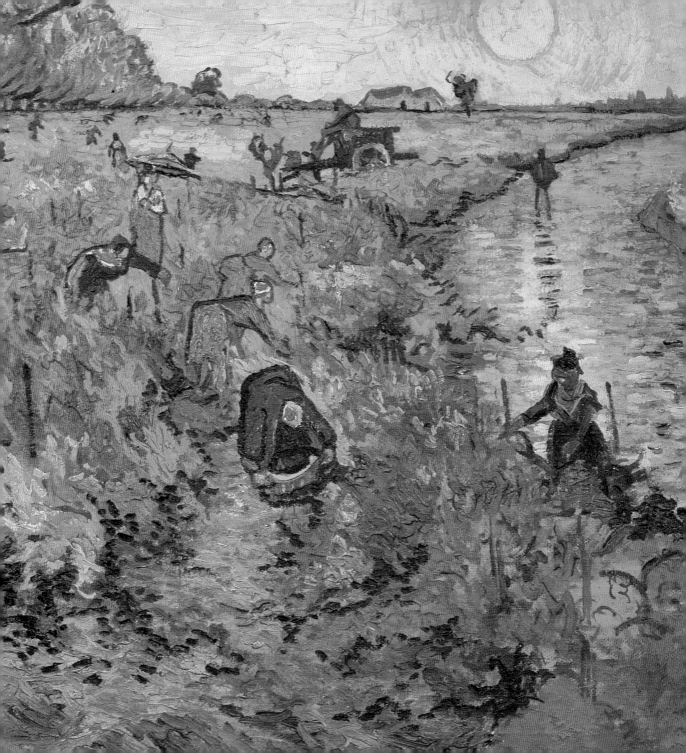

▷ **Pollarded Willows and Setting Sun** 1888

Oil on canvas

THIS DRAMATIC PAINTING brings together a number of natural phenomena that stimulated van Gogh's imagination. The sun was a symbol of life and, conversely, of death at its setting, while pollarded willows were a symbol of the resurrection that comes to nature in springtime. 1888 was an ominous year for van Gogh for it was the year of his first mental collapse. The painting was probably a study for a later, even more intense, version of the scene near Arles, with a burning red sun setting behind a sower on a dark field with a pollarded tree in the foreground.

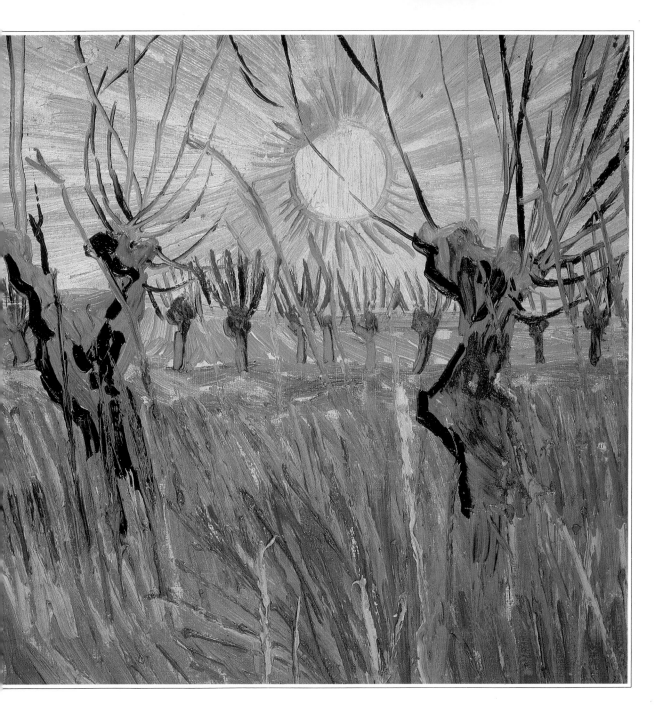

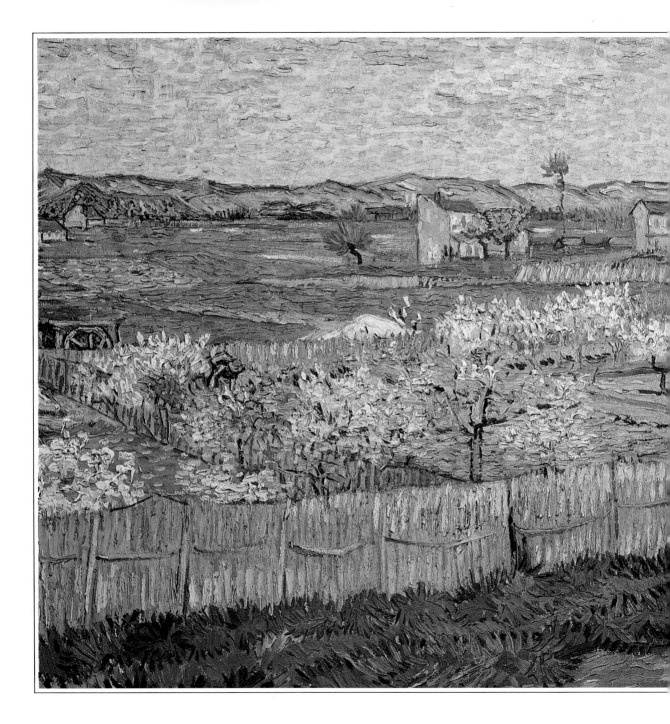

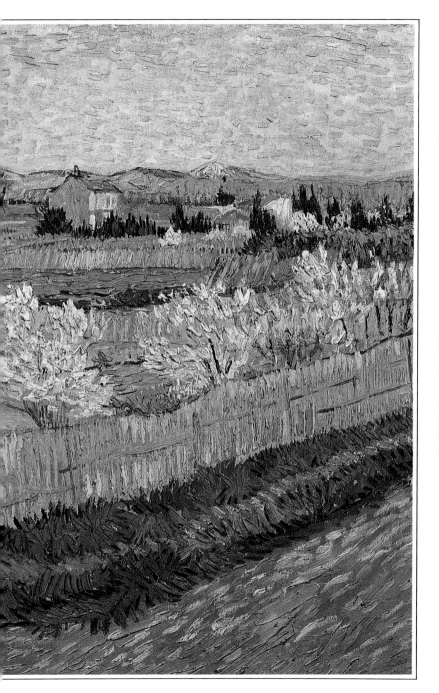

◁ **Peach Blossom in the Crau** 1889

Oil on canvas

THE CRAU IS THAT PART of Provence that lies south of Arles, separated from the Camargue by the Rhône. It is a flat area of reclaimed land where fruit orchards abound. The agricultural land, perhaps reminding him of the fields at Brabant but here brilliant in sunshine, inspired van Gogh with their message of life and hope. He did two of his earliest Provençal paintings here, one in spring with the fruit trees all in blossom and the other at harvest-time. In the period between the two paintings van Gogh had suffered his first attack of madness.

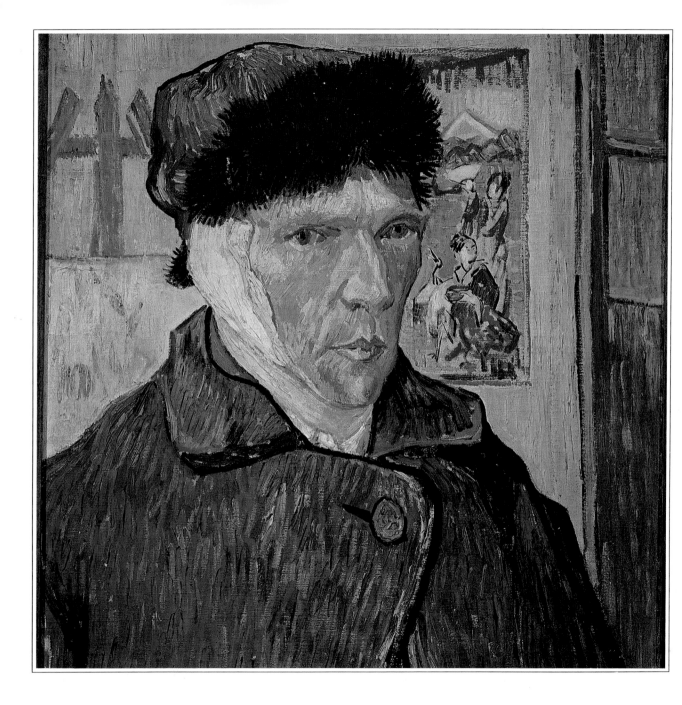

◁ **Self-portrait with Bandaged Ear** 1889

Oil on canvas

VAN GOGH CUT OFF part of his ear in December 1888, after a quarrel with Gauguin, with whom he had been sharing a house, the Yellow House in Arles. The two painters, although friends, often did not get on, Gauguin even threatening to return to Paris. One evening, as he walked in the public gardens Gauguin saw van Gogh approaching him in a threatening manner and decided to spend the night at a hotel. Next day, on returning to the Yellow House, he found the police there, van Gogh having been taken to hospital, almost lifeless. Apparently, he had presented the severed ear to a prostitute at the local brothel, and returned home to lie bleeding all night in his bed.

△ **Self-portrait** 1889

Oil on canvas

THE MANY SELF-PORTRAITS that van Gogh did during his brief painting life are a barometer of his moods. In all of them there is an anxious look in the eyes, as if he is worried about the identity of the person who stares back at him from the mirror. . . Having tried being an art dealer, a preacher and a language teacher, van Gogh had been financially dependent on his brother throughout his life as a painter. The fact that Théo was now in trouble with his job and had a sick son must have caused Vincent deep anxiety, which shows in this portrait.

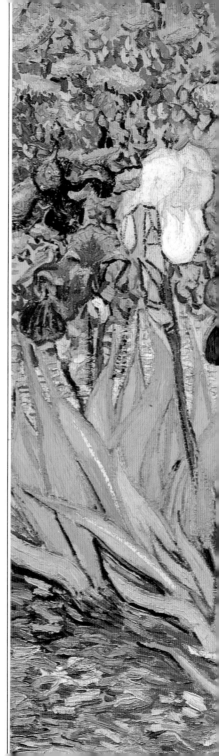

▷ **Irises** 1889

Oil on canvas

THE IRISES THAT GREW in the garden of the asylum at St-Rémy-de-Provence had attracted van Gogh's attention as soon as he arrived there. The intense colour of their flowers, contrasting with the green spears of the stems growing out of the dry soil, gave him courage and faith in the strength of nature in difficult conditions. In this painting, one of many of the flowers van Gogh was to paint, the deep red soil in which the irises are growing becomes towards the top of the picture an airy green, seeming to suggest a transition from shadow into light and freedom – perhaps an unconscious symbolism in van Gogh's mind.

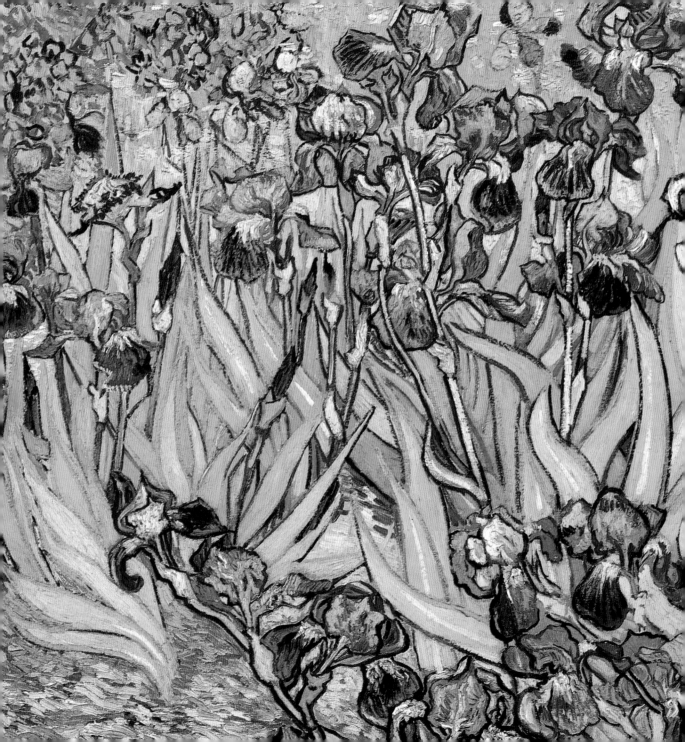

▷ **Portrait of
Dr Felix Rey** 1889

Oil on canvas

DR REY WAS the house surgeon
who treated van Gogh in the
Arles hospital after he
mutilated his ear. The doctor
had told him not to worry, that
he was anaemic and needed
feeding up. As the wound
healed and van Gogh
recovered, he felt confident
that his crisis had been a
temporary affliction and wrote
to his brother and to Gauguin
to reassure them. He evidently
became friendly with Dr Rey
with whom he 'walked for an
hour and a half and talked
about everything, even about
natural history.' He also
painted the doctor's portrait
which he gave him as a
keepsake; the doctor evidently
did not think much of it, for
he used it to mend a hole in
his chicken house.

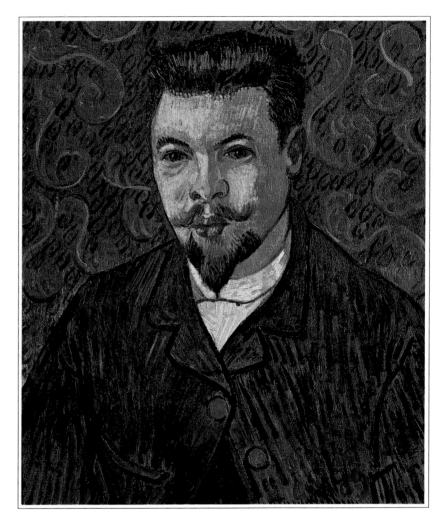

▷ **St Paul's Hospital, St-Rémy** 1889

Oil on canvas

THIS OUTDOOR VIEW of the asylum at St-Rémy-de-Provence shows a typical country house in Provence with a fine portico and balcony and green shuttered windows. It was a pleasant facade concealing the tragic interior with its dormitories of pathetic, unbalanced people among whom van Gogh chose to spend a year after his breakdown in Arles. Van Gogh had his own little room and was free to come and go as he pleased. According to Dr Peyron, who was in charge of the hospital, van Gogh was suffering from 'acute mania with hallucinations of sight and hearing and epileptic fits at very infrequent intervals.'

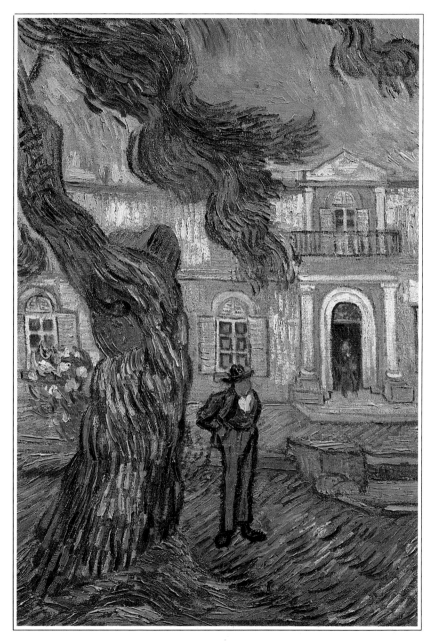

▷ **The Olive Grove** 1889

Oil on canvas

VAN GOGH PAINTED 15 olive
grove pictures at St-Rémy-de-
Provence. He had discovered
in this ancient source of oil for
the early Mediterranean
civilizations a subject of infinite
variety and colour. When the
tree was in flower he saw it in
tones of all-pervading blue,
with emerald cicadas and rose
beetles and blue butterflies
hovering round it. In the
scorched grass around them
the trees seemed green and
fresh. They changed with
every change in the weather.
With the olive trees van Gogh
developed the sinewy
brushstroke which
characterized his later work.
In this picture he introduces a
human interest in the form of
the olive-pickers up a ladder
and turns a symbolic picture
into one recording a familiar
rural scene.

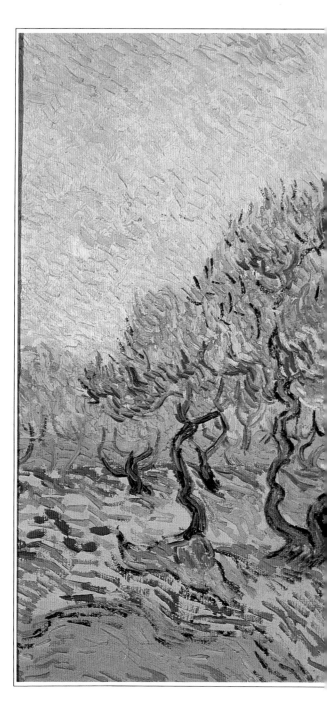

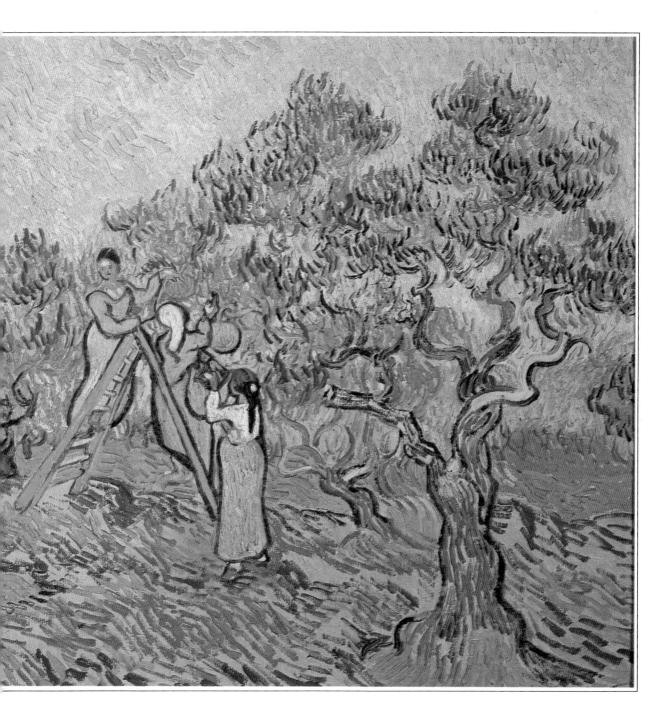

▽ **Cornfield with Cypresses** 1889

Oil on canvas

THIS WAS PAINTED during the summer at St-Rémy-de-Provence while van Gogh was recovering from his first bout of mental illness and the artist's stress clearly shows in the turmoil of the clouds and sky. The presence of cypresses in van Gogh's paintings always gave a sense of foreboding, but he was writing cheerfully to his brother at this time. Théo had returned to Paris, after visiting him following the ear-cutting incident late in December 1888.

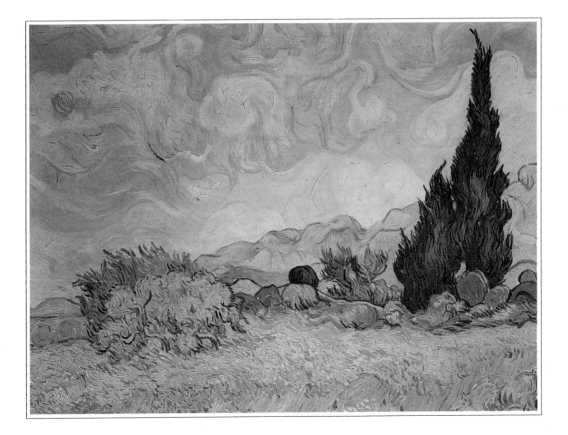

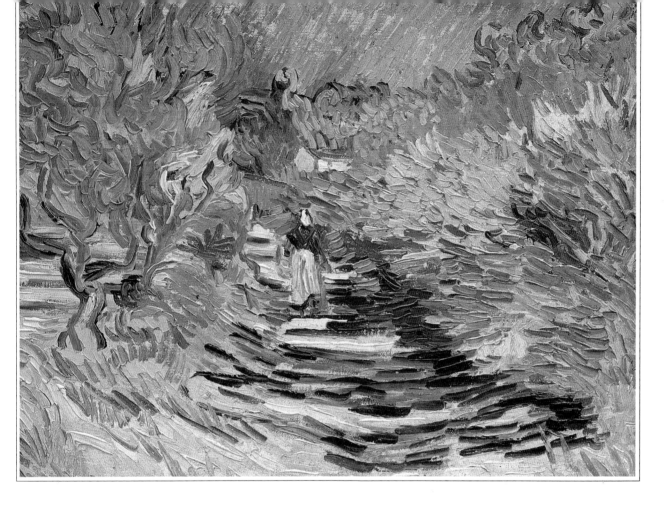

△ **A road in St-Rémy** 1889

Oil on canvas

AFTER HIS MENTAL breakdown, van Gogh went voluntarily to a mental hospital, St-Paul-de-Mausole, at St-Rémy-de-Provence. Here he had his own bedroom and a studio in which to work. Apart from his attacks, which could last days or weeks, he was quite lucid and spent much time painting. It was while he was here that van Gogh began painting cypress trees, and his brushstrokes became more violent and forceful, though controlled. The road at St-Rémy caught his imagination as he walked in the foothills of the limestone ridge of Les Alpilles which lay to the south of the town.

▷ **The Starry Night** 1889

Oil on canvas

THIS INTENSE PAINTING of a night sky was done in St-Rémy-de-Provence. Its awesome grandeur and turbulent starlight seem to reflect van Gogh's feelings that he was only an instrument in the creative process of the universe. In a letter to Théo he wrote 'That is the eternal question, is life all that there is of life or do we only know one hemisphere before our death? Speaking for myself I have no idea what the answer is but the sight of the stars always starts me thinking.'

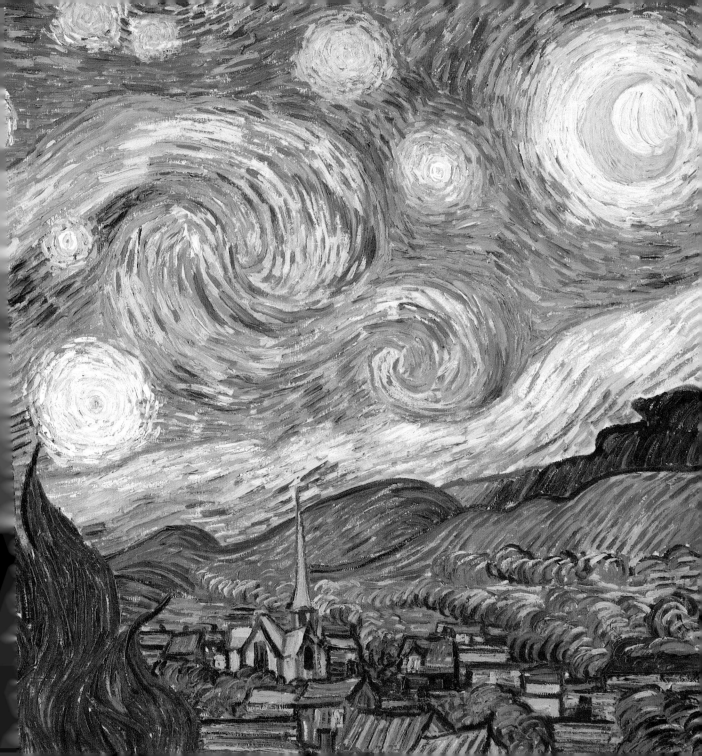

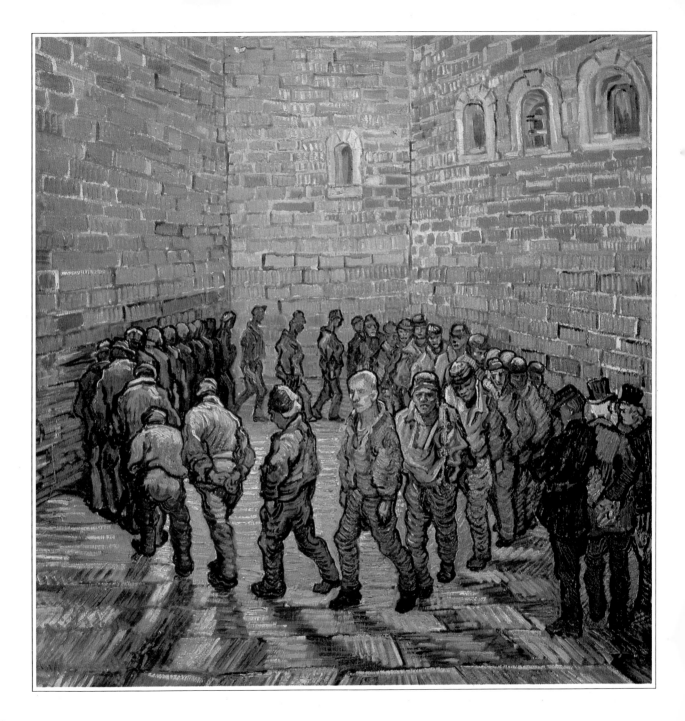

◁ **The Exercise Yard** 1889

Oil on canvas

THIS PAINTING was made by van Gogh from a copy of a Gustave Doré print of Newgate prison in London and may reveal the painter's feelings about being at the lunatic asylum at St-Rémy-de-Provence. Although he had gone there voluntarily, not wanting to be alone after his illness at Arles, he had been considerably shocked at meeting the asylum's inmates. After an artistically busy year during which he produced scores of paintings, he wanted to get away. 'My surroundings here begin to weigh on me,' he wrote to his brother, 'I have been a patient for more than a year . . . I can't go on, I am at the end of my patience, my dear brother, I can't stand any more. I must make a change – even a desperate one.'

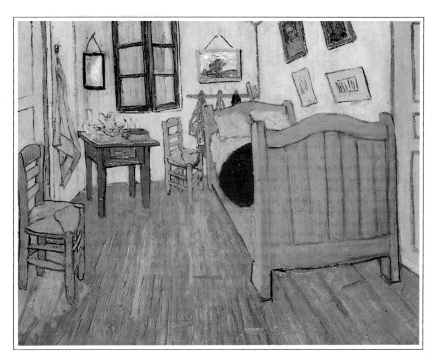

△ **Van Gogh's Bedroom at Arles** 1889

Oil on canvas

THIS CHEERFUL PAINTING of his bedroom in the Yellow House, which van Gogh painted several times, is evidence of his need for a niche of his own in life where he could feel safe. He did one version of the bedroom at Arles, then two more at the lunatic asylum at St-Rémy-de-Provence. Writing to Gauguin van Gogh said that it had entertained him enormously 'to do this simple interior with a Seurat simplicity; flat colour, but thickly brushed on in flat impasto, the walls pale lilac, the floor in a broken and faded red, the chair and bed in chrome yellow, pillows and sheets in very pale lemon green, the washstand blue, the window green.'

▷ **Noon (after Millet)** 1890

Oil on canvas

VAN GOGH'S ADMIRATION for romantic painters like Millet and Delacroix found expression in numerous paintings, though their subjects were treated very much in van Gogh's own style. With this picture of two peasant farm workers resting at midday, van Gogh returns to the idea of the nobility of work which had inspired many of his early, Dutch period painting. Unlike their Brabant counterparts, these peasants live in a sunny and bountiful land and are painted in light colours, in contrast to the dark browns of his Dutch paintings. Throughout his life, van Gogh never doubted the dignity of human life; even his dire personal problems did not make him lose faith in human endeavour.

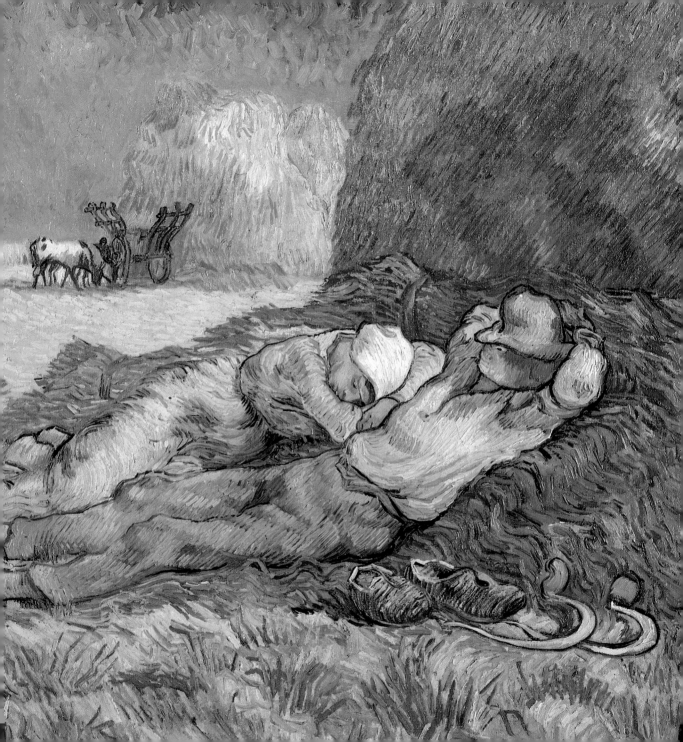

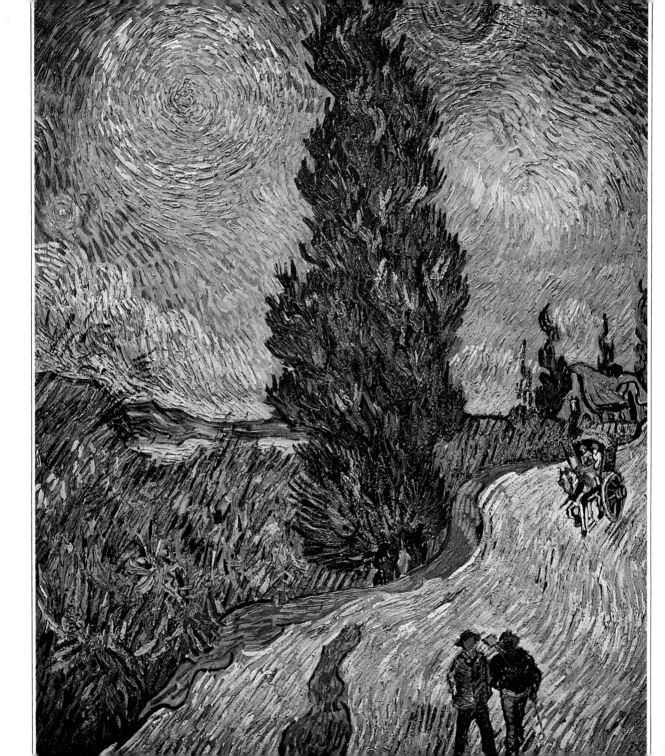

◁ **Cypresses with Two Figures** 1890

Oil on canvas

CYPRESSES, which featured more and more frequently in van Gogh's last paintings, fascinated him, though at first he found them difficult to paint. They seemed to take a dominant part in the landscape, because of both their form and their colour. He told his brother in 1889 that the cypresses were always occupying his thoughts. 'It astonishes me that they have not yet been done as I see them . . . a splash of black in a sunny landscape, but it is one of the most interesting black notes and the most difficult to hit off exactly.'

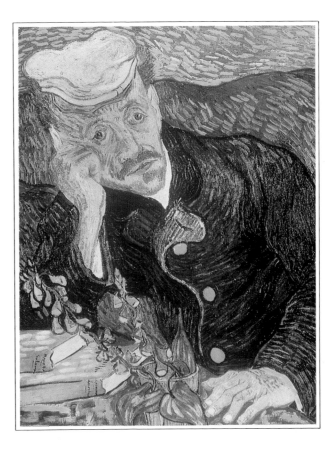

△ **Portrait of Dr Gachet** 1890

Oil on canvas

ALTHOUGH VAN GOGH did not have much confidence in Dr Paul Gachet, a heart specialist at Auvers-sur-Oise recommended to van Gogh's brother by the painter, Pissarro, he evidently liked the man, who was also an art collector and amateur artist. Dr.Gachet had agreed to keep an eye on the painter, who was living at an inn run by the Ravoux family, and soon became a good friend. He often invited van Gogh to his house to meet his family. The result was several paintings of the Gachet family, as well as the Ravoux family.

Van Gogh's portrait of the doctor is an arresting study of this melancholy man whose expression, the painter said, would seem like a grimace to many who saw the canvas but whom he knew to be a sad but gentle soul, dear and intelligent.

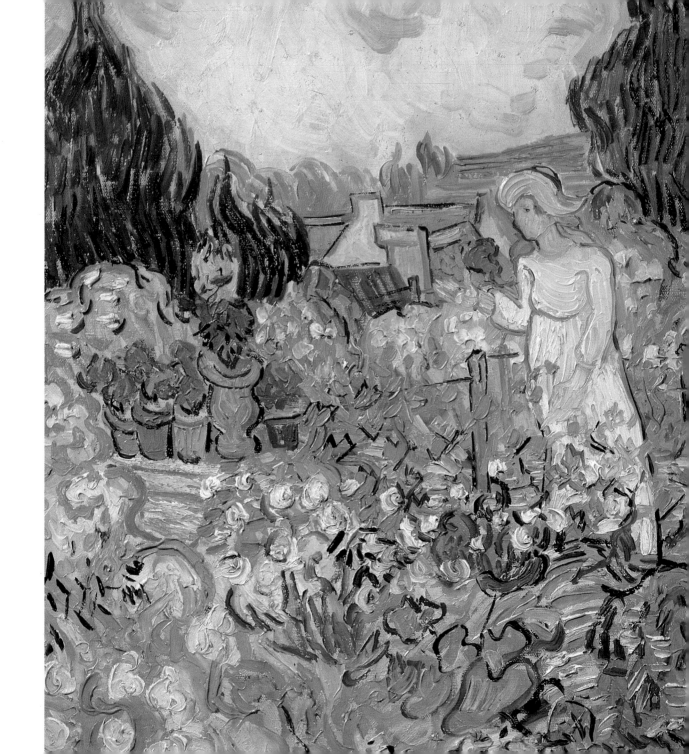

◁ **Mademoiselle Gachet in the Garden at Auvers** 1890

Oil on canvas

WITHIN A WEEK of his arrival at Auvers-sur-Oise, van Gogh was in Dr Gachet's garden, setting it on canvas in vivid bursts of strong colours. His second painting in the garden was a study with 'white roses, a vine and a white figure walking among them', as he described the picture to his brother. The white figure was Mlle Marguerite Gachet, the doctor's daughter. Van Gogh was to do a much less sketchy portrait of the girl, *Marguerite Gachet at the Piano,* later.

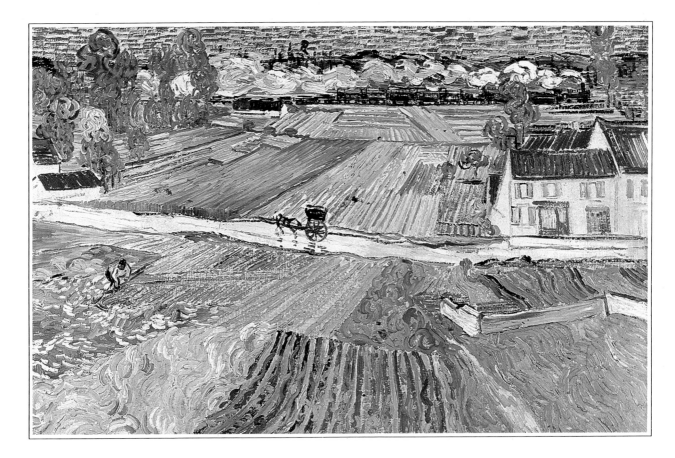

△ **Landscape at Auvers after Rain** 1890

Oil on canvas

THE NORTHERN LANDSCAPE to which van Gogh returned after his year in Provence was very different from that of the south. To accommodate it he modified the colours of his palette. Although cooler in tone, the outdoor Auvers paintings have the full, clean colouring applied vigorously in the way he had developed in Arles and St-Rémy-de-Provence. Just a month before his death the burning yellow of the southern sun had returned in his *Wheatfields with Crows*, a tormented landscape which was one of the last he painted, but in this painting blue is the predominant colour, with the red roofs of the houses for contrast.

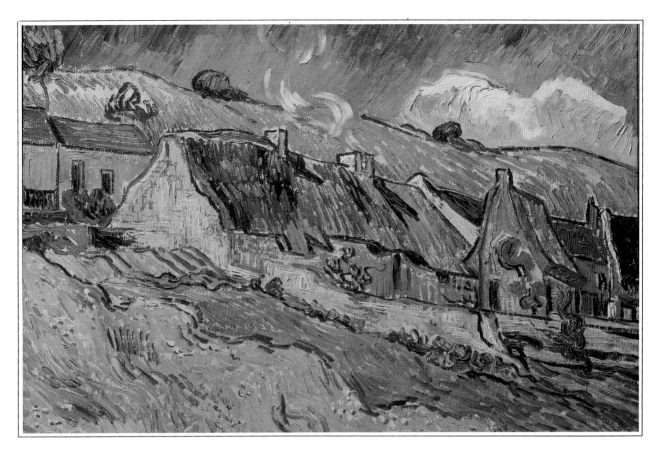

△ **Row of Houses at Auvers** 1890

Oil on canvas

VAN GOGH'S JOURNEY to Auvers-sur-Oise early in 1890 was another step in the retreat from the hopes he had cherished when he left Paris for Arles in the warm south of France. He had returned north to be near his brother, Théo. Even so, he was still painting with power and apparent confidence in his abilities. In this picture of cottages at Auvers (of which he painted several different views), he has omitted the tormented skies and black crows of his blacker moments of despair in the south; instead, there are the bright, clear colours of summer in northern France.

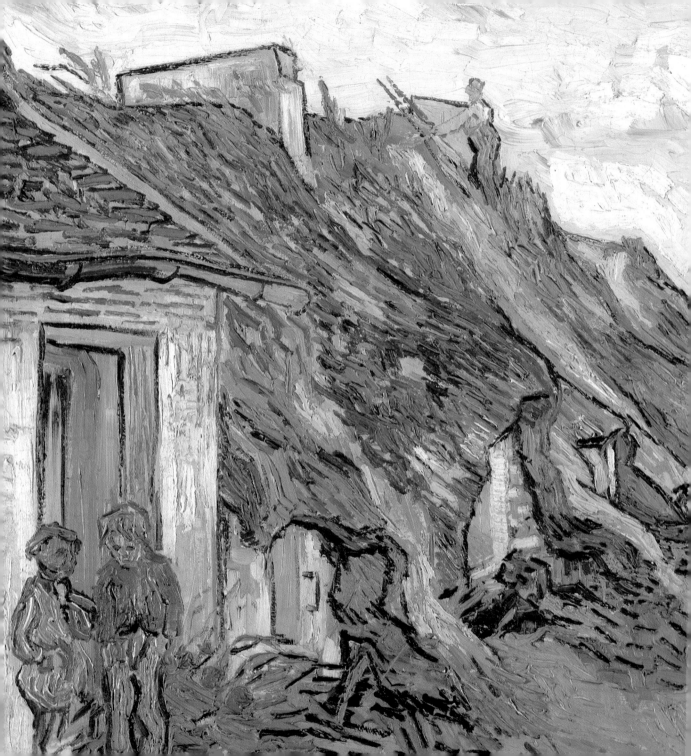

◁ **Thatched cottage in Auvers** 1890

Oil on canvas

THIS IS ONE of the last paintings that van Gogh completed before he shot himself in the chest in July, 1890, dying two days later. It came after the ominous *Wheatfield with Crows;* although the brushwork is turbulent, the scene as a whole has a rural calm. The sketch for the painting was enclosed in van Gogh's last letter to his brother, in which he sympathises with Théo's personal problems and bemoans the lack of understanding with dealers and artists.

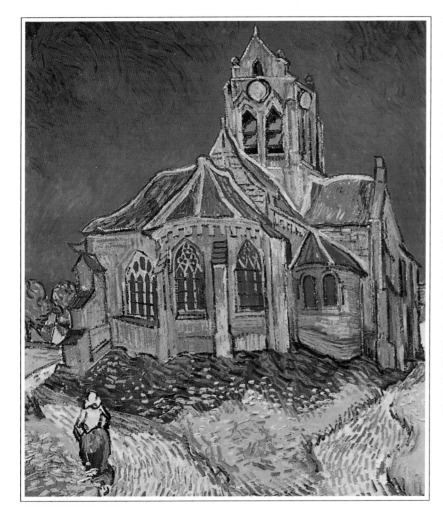

◁ **The Church at Auvers** 1890

Oil on canvas

WHEN VAN GOGH painted the rather sombre picture of the local church at Auvers, he could not have guessed that its priest would refuse to bury him in the graveyard a few weeks later because he had shot himself. Despite the tumultuous state of his mind, aggravated by his brother's business and domestic problems, van Gogh was very calm and clear in his assessment of the painting: 'The building is violet against a sky of simple deep blue, pure cobalt, the stained glass windows appear as ultramarine blotches and the roof is violet and partly orange.'

ACKNOWLEDGEMENTS

The Publisher would like to thank the following for their kind permission to reproduce the paintings in this book:

Glasgow Museums : Art Gallery & Museum Kelvingrove 2425, 10-11; **The Museum of Modern Art, New York. Acquired through the Lillie P. Bliss Bequest. Photograph © 1994 The Museum of Modern Art, New York,** 64-65; **Musée d'Orsay, Paris © Photo-RMN** 68-69; **Vincent Van Gogh (Stichting/Foundation)/Van Gogh Museum, Amsterdam** 8-9, 18-19, 40-41; **KunstmuseumWinterthur,**32-33; **Kunsthaus Zürich, Zürich** 76-77.

Bridgeman Art Library, London /Boston Museum of Fine Arts, Mass. 42; /**Christie's, London** 34, 46; /**Courtauld Institute Galleries, University of London** 52-53, 54; /**Fogg Art Museum, Harvard University, Cambridge, Mass.** 23; /**Gemäldegalerie, Kassel** 31; /**J Paul Getty Museum, Malibu, California** 56-57; /**Giraudon /Musée D'Orsay, Paris** 25, 26-27, 55, 59, 67, 72-73, 78; /**Giraudon /Museu de Arte de São Paulo** 45; /**Hermitage, St Petersburg** 28-29, 58,75; /**Musée d'Orsay, Paris** 12-13; /**Museum Boymans-Van Beunigen, Rotterdam** 44; /**National Gallery, London** 62; /**National Gallery, London/Index** 24; /**National Gallery of Art, Washington DC** 60-61; /**Niarchos Collection, London** 36-37; /**Phillips Collection, Washington DC** 38-39; /**Private Collection** 14-15, 22, 35, 43, 48, 63, 71; /**Pushkin Museum, Moscow** 30-31, 48-49, 66, 74; /**Rijksmuseum Kröller-Müller, Otterlo** 16,17, 47, 50-51, 70; /**Rijksumuseum Vincent Van Gogh, Amsterdam** 20-21.